ARTIST'S HANDBOOK:

OILS

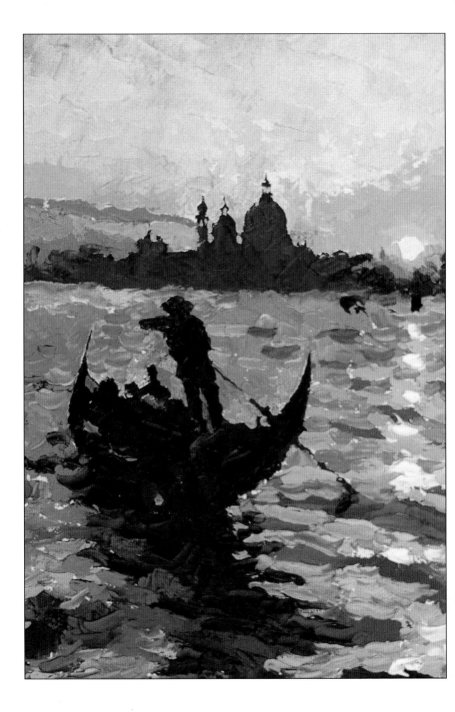

ARTIST'S HANDBOOK:
OILS

materials • techniques • color and composition • style • subject

Contents

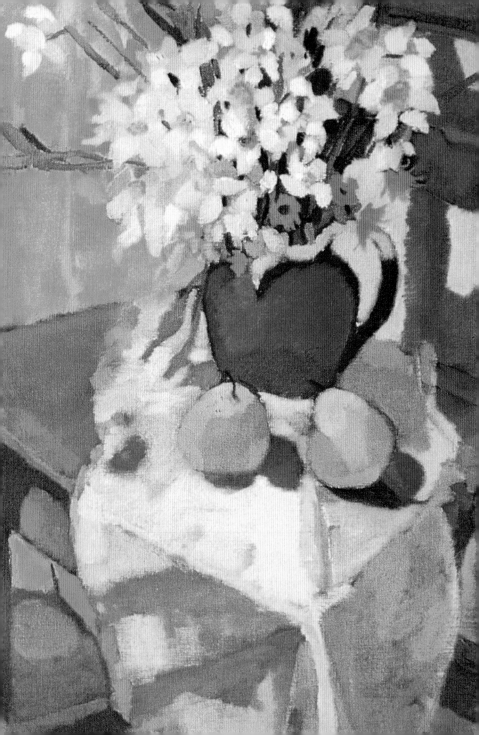

INTRODUCTION

Oil paint is probably the most popular of all the painting media, both with amateurs and professionals. When it was first introduced, artists had to go through the laborious process of grinding their own pigments, but since the 19th century a succession of technical advances has been made, and a huge range of high-quality colors in convenient and portable tubes is now available to everyone.

One can learn a lot by trial and error, but it saves time and frustration to know the "language" of painting. This is what the book sets out to teach, with a series of articles and demonstrations outlining the main oil painting techniques, both traditional and modern. Ultimately, each artist must find his or her own means of expression through paint, but a knowledge of what is possible in terms of technique makes the task much easier.

OILS

In recent decades there has been an amazing proliferation of new materials for artists and designers, so much so that a visit to one of the larger art supply stores can leave an uninitiated person feeling confused and bewildered. There are pencils, pens, crayons, and pastels in every color of the rainbow; there are acrylic paints, both in tubes and in pots; there are watercolors in tubes, pans, and boxes; there are gouaches and poster paints; there are even special paints for fabrics and ceramics. Indeed, special materials are now available for almost any surface that could conceivably be painted or decorated. And, often tucked away unobtrusively in one corner, there are oil paints.

Why then, are oil paints still so popular with professional artists and "Sunday painters" alike? There are two main reasons for this, the first being that oil paint is the most versatile of all the painting media, and can be used in any number of ways to suit all styles, subjects, and sizes of work. The second is that it is the easiest medium for a beginner to use. Which is not to say, of course, that a novice will automatically be able to create a masterpiece on the first try – that is very unlikely. But because oil paint can be manipulated, scraped off and overpainted, built up and then scraped down once again, it enables you to learn by trial and error, uninhibited by

the thought of having "to start all over again," or waste expensive materials. This is not true of any other medium: acrylic for example, cannot be moved at all once it has been laid down, and watercolor quickly loses all its qualities of freshness and translucence if overworked. Of course, an overworked oil painting will not be a perfect picture, but it may at least be a creditable one, if only because of the knowledge gained in painting it.

Oil paint, though regarded as a "traditional" painting medium, is actually quite young in terms of art history. In Europe, before the invention of oil paint in the fifteenth century, artists painted with tempera, which is color pigment bound with egg yolk. This was a difficult medium to use as it dried very fast, and thus called for a deliberate and meticulous approach.

The Flemish painter Jan van Eyck (c.1390–1441) was the first to experiment with raw pigments bound with an oil mixture, when he found that

one of his tempera paintings had split while drying in the sun. Not only did the oil paints dry without cracking, but, as van Eyck discovered, they could be applied in thin, transparent layers that gave the colors a depth and luminosity hitherto unknown.

The early painters in oil, like van Eyck, used the paint thinly, with delicate brush strokes that are almost invisible to the eye. But the full potential of oil paint was not really exploited until it was taken up by the Italian painters of the fifteenth and sixteenth centuries, notably Giorgione (1475–1510) and Titian (c.1487–1576).

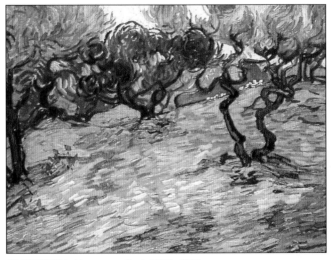

OLIVE TREES by Vincent van Gogh (1853–1890)

The Impressionists' use of paint was free and daring by the academic standards of the day, but van Gogh's was the most innovative by far.

In Titian's hands, and later in those of the great Dutch painter, Rembrandt (1606–1669), oil paint was at last used with a feeling for its own inherent qualities. Both artists combined delicately painted areas of glazing with thick brush strokes in which the actual marks of the brush became a feature rather than something to be disguised.

The English landscape painter, John Constable (1776–1837), and the French Impressionists later in the nineteenth century, took the freedom of painting to even greater lengths by using oil as a quick sketching medium, often working outdoors.

The very diversity of painting techniques in the past has had the effect of freeing us from any preconceptions about the medium. It is exactly what you want it to be.

OIL PAINT TODAY

Today's painters use oil paint in so many different ways that it is often hard to believe that the same medium has been used. Interestingly, the art of tempera painting is now undergoing a revival, and some artists working in oil use a similar technique, applying thin layers of transparent glazes to produce a luminous, light-filled quality. Other artists apply paint thickly with a knife, building it up on the surface of the canvas so that it resembles a relief sculpture.

New painting mediums – oils, varnishes, and extenders – are constantly being developed in recognition of these different needs; for example, you can choose one type of medium if you want to build up delicate glazes, another if you want to achieve a thick, textured surface using the impasto technique.

Oil paints can be mixed with other types of paint and even other media; for instance, they can be used in conjunction with oil pastels for quick

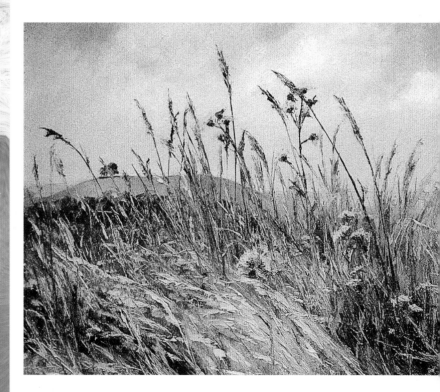

and dramatic effects; they can be drawn into with pencils; and some artists even mix paint with sand to create areas of texture. A later chapter treats such special techniques in more detail, but the foregoing should give you some idea of the creative potential of this exciting and adaptable medium.

GRASSES NEAR COOMBE HILL by
Brian Bennett

In this unusual painting the artist has chosen a low viewpoint so that the foreground effectively becomes the whole picture. The flowers and grasses have been painted with a palette knife, which can give fine, linear effects when used on its side (see Knife Painting pages 48–49).

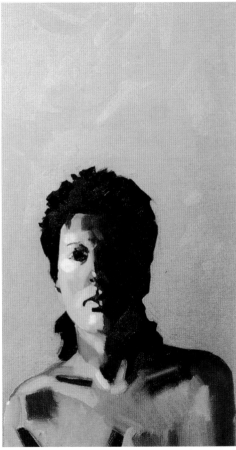

In complete contrast to the delicate transparency of watercolor, oil paints can be laid on with thick impasto to produce a heavily textured result. In this striking portrait, the artist worked alla prima, applying all the paint in the same stage and working wet-in-wet over a beige ground.

MATERIALS

The first step in learning to draw or paint is to familiarize yourself with just what you will need to use. This might seem obvious, but too many people are either put off by what they see as unnecessary outlay or they go and buy everything for a particular medium only to find most of their purchases gathering dust. These pages provide a sensible guideline for learning about the medium, with practical advice on how to build up an effective collection of materials and equipment.

Materials for oil painting can be costly, so it is advisable to work out your "starter kit" carefully. Begin by buying the minimum and adding extra colors, brushes, and so on when you have progressed to the stage of understanding your particular requirements.

CHOOSING PAINTS

Oil paints are divided into two main categories; artists' and students' colors. The latter are less expensive because they contain less pure pigment and more fillers and extenders, but in general they are a false economy for that very reason; they cannot provide the same intensity of color as the more expensive range. However, students' colors are fine for practicing with, and it is possible to combine the two types using the students' colors for browns and other colors where intensity is not a prime requirement, and artists' for the pure colors such as red, yellow, and blue. A large tube of white works out to be the most economical, since white is used more than most other colors.

Paints in the artists' range are not all the same price – a trap for the unwary. They are classified in series, usually from 1 to 7 (different manufacturers have different methods of classification), series 7 being extremely expensive. The price differences reflect the expense and/or scarcity of the pigment used. Nowadays, because there are so many excellent chemical pigments, it is seldom necessary to use the very expensive colors, such as vermilion, except in very special cases.

It is often said that all colors can be mixed from the three primaries, red, yellow, and blue. To some extent this is true, but they will certainly not provide a subtle or exciting range, and in any case there are a great many different versions of red, yellow, and blue. The illustration shows a suggested "starter palette," that should provide an adequate mix of colors for most purposes. In general you will need, as well as white, a warm and a cool version of each of the primaries, plus a brown and a green and perhaps a violet or purple. Strictly speaking, greens are not essential as they can be mixed to arrive at the right hue, and there really is not much point in spending more time in mixing than you need. Viridian is a good choice, since it mixes well with any color. Other useful additions to your palette are rose madder in the red group; a lemon yellow such as Winsor or cadmium lemon in the yellow group; cerulean blue and Antwerp or cobalt blue in the blue group; and sap green and chrome green in the greens. Good browns and grays are burnt sienna, burnt umber, and Payne's gray. Flake white dries quickly and is resistant to cracking, but it contains poisonous lead; for this reason some artists prefer to use titanium white, which is nontoxic. The use of black is often frowned upon, and many artists never use it as it can have a deadening effect, but it can be mixed

with yellow to produce a rich olive green, and many landscape artists use it for this purpose.

THE BASIC PALETTE

Professional artists seldom use a large range of colors, preferring to gain their effects through mixing. Some use no more than five colors, and a perfectly satisfactory picture can be painted with only the three primaries plus white and possibly black. Our basic palette, here, contains 12 colors, giving many possible permutations. This is only a suggested list – if you wish you may substitute colors of your own.

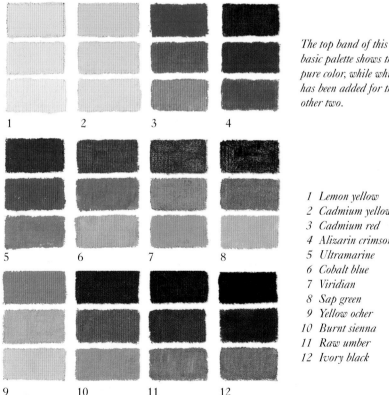

The top band of this basic palette shows the pure color, while white has been added for the other two.

1 *Lemon yellow*
2 *Cadmium yellow*
3 *Cadmium red*
4 *Alizarin crimson*
5 *Ultramarine*
6 *Cobalt blue*
7 *Viridian*
8 *Sap green*
9 *Yellow ocher*
10 *Burnt sienna*
11 *Raw umber*
12 *Ivory black*

CONSTITUENTS AND PROPERTIES

The word "medium" embraces all the different fluids used both in painting and the manufacture of paint. They fall into four categories.

BINDERS

Binders are the drying oils that are mixed with pigment particles in the manufacture of paints to form a thick paste. They are usually linseed oil and, for the paler pigments, poppy oil, and they are called drying oils because they dry upon exposure to air.

MEDIUMS

Mediums are oils or synthetic "oils" used in the course of painting. Their purpose is to change or enhance various properties of paint, such as consistency, drying time, and glossiness. Linseed and poppy oil are also used in this context.

DILUENTS

Diluents are liquids that may or may not act as solvents, used to dilute and thin down paints to aid their application. They evaporate once exposed to the air, leaving paint of the original composition. Turpentine and white spirit are the most-used diluents.

VARNISHES

Varnishes are liquids designed to cover a finished painting in order to protect it and to provide the desired matte or glossy finish.

The binders, mediums, and varnishes are all mixtures of one or more of the following: drying oils, resins, waxes, diluents, and siccatives. All of these may either be natural or synthetic. The resins, such as damar, mastic, and copal, contribute toward a hard protective film in varnishes and add gloss to paint mediums. Waxes such as beeswax are used in glazing mediums and also in those designed to improve the impasto effect of paint. Siccatives are drying agents, usually containing lead, manganese, or cobalt, sometimes added to the medium. Some paints will already contain these,

and will consequently be quick driers. An art supply store is usually stocked with a daunting array of bottles, but actually the beginner need purchase nothing more elaborate than one bottle of distilled turpentine with which to thin paints for the initial layers of underpainting, and one bottle of refined linseed oil. The latter, diluted with at least twice its volume of turpentine, gives a fatter, glossier texture to the final layer of paint. You will also need white spirit for washing brushes, but this is usually more cheaply obtained from hardware and DIY stores. It is a cheap mineral turpentine substitute that can also be used as a diluent and is useful for those who are allergic to turpentine.

If in time you find that the basic linseed–oil turpentine mixtures do not suit your needs, the only course is to experiment with other mediums until you find one or more that you are happy with. All manufacturers provide information on their products, so it is wise to consult these before making your choice. You may decide to dispense with a medium altogether; there is no reason why paint should not be applied neat, particularly for

impasto areas such as highlights, laid toward the end of a painting.

From left to right: gloss varnish, retouching varnish, and matte varnish.

BRUSHES AND KNIVES

Paint brushes for oil painting come in a wide range of shapes, sizes and materials. Good-quality brushes cost more, but are worth the initial outlay as they last longer and hold their shape better. For oils, unlike for watercolors, you need more than just one or two brushes, otherwise you will be forever cleaning them between applying one color and the next. The ideal is to have one brush for each color, but a selection of six should be enough to start off with. The illustration shows the main shapes and types of brush.

FLATS

Flats have long bristles with square ends. They hold a lot of paint and can be used flat, for broad areas, or on edge for fine lines.

BRIGHTS

Brights have shorter bristles than flats and produce strongly textured strokes. They are ideal for applying thick paint for impasto effects.

ROUNDS

Rounds have long bristles, tapered at the ends. Like flats, they produce a wide variety of strokes, but they give a softer effect that is excellent for backgrounds, skies, and portraits.

FILBERTS

Filberts are fuller in shape than flats, with slightly rounded ends that make soft, tapered strokes.

Of the four types of brush, rounds and flats are the most useful to begin

Soft sable brushes

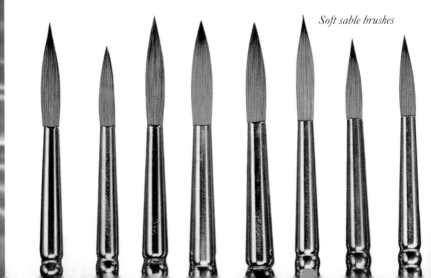

with. Brights and filberts can be added later, should you require them.

Each type of brush comes in a range of up to 12 sizes; so choose the size that best suits the style and scale of your paintings.

Hog's-hair bristles and sable hair are the traditional materials for oil-painting brushes; hog's hair is fairly stiff and holds the paint well, while sable gives a much smoother and less obvious brush stroke. Sables are very expensive indeed, but there are now several synthetic versions of the softer type of brush, and also mixtures of sable and synthetic. In the case of the soft brushes, you may need several or

none at all, according to the way in which you work; some artists use nothing but soft nylon brushes and others nothing but hog's hair. The projects later in this book will give you an idea of the differing requirements of different styles.

Palette knives, made of flexible steel, are used for cleaning the palette and mixing paint, while painting knives are designed specifically for painting. The latter are unlikely to be needed by a beginner unless you have a particular desire to experiment with this kind of painting, but an ordinary straight-bladed palette knife should form part of your "starter kit."

From left to right: A range of brush types used for particular techniques. Fine synthetic round, broad synthetic round, mixed fibers round, ox hair round, squirrel hair round, sable fan, sable bright, sable round, fine sable round.

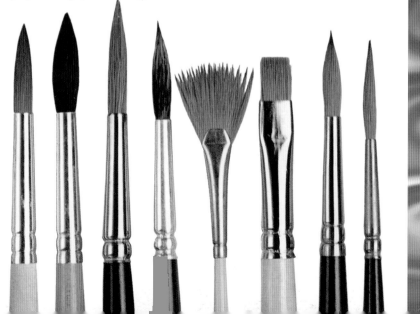

ACCESSORIES

Other essential items include dippers for your painting medium, which can be attached to the palette; jars or cans to hold white spirit for cleaning brushes; and of course a large supply of rags or paper towels (oil paint is very messy and needs to be cleaned up frequently).

Another useful painting aid is a mahl stick, which steadies your hand when you are painting small details or fine lines. The traditional mahl stick has a bamboo handle with a chamois cushion at one end. The stick is held across the canvas with the cushioned end resting lightly on a dry area of the painting, and you rest your

painting arm on the stick to steady yourself as you paint.. Mahl sticks are sold at art supply stores, but a piece of dowelling or garden cane with a bundle of rags tied to one end is quite adequate, and can be rested on the side of the canvas or board if the paint surface is wet.

For anyone who intends to do a lot of outdoor work, a pair of canvas separators is very useful. These are designed to keep two wet canvases apart without damaging the paint, and have a handle for carrying. It is necessary to have two canvases of the same size with you, even if you intend to use only one.

Mahl stick

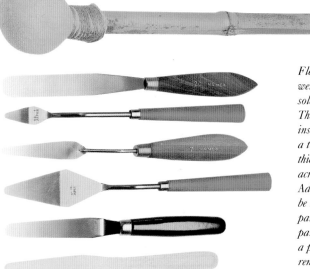

Flexible palette knives were originally used solely for color mixing. They can be used instead of a brush, as a tool for laying on a thick impasto of oil or acrylic paint. Additionally, they can be used to scrape away paint when a particular passage in a painting needs to be removed.

PALETTES

Palettes come in a variety of shapes, sizes, and materials, designed to suit your individual requirements. Thumbhole palettes are designed for easel painting. They have a thumbhole and indentation for the fingers and the palette is supported on the forearm. Before buying a palette, try out different sizes and shapes to see which feels the most comfortable.

New wooden palettes should be treated by rubbing with linseed oil to prevent them from absorbing the oil in the paint. You can even improvize your own palette, from any nonabsorbent surface, making it any size and color you like.

A sheet of glass with white or neutral-colored paper underneath it would be suitable, or there are disposable palettes made of oil-proof paper – these are a boon for outdoor work, and remove the necessity for cleaning. The object to most closely fulfill all the conditions for the ideal palette is a large china plate. A white plate has an advantage, because white allows mixtures of color to be accurately gauged. A colored surface can play optical tricks and is best avoided.

Another possible palette is a sheet of plain white plastic. The advantage here is that it can be bought in any size.

You will need containers for your turpentine, mineral spirits, oil, and medium. A large jar will do very well for the spirits for cleaning your brush, but smaller containers called dippers are useful for holding the working mediums. Dippers are small metal pots with clips that attach firmly to the palette. They come singly or in pairs, and some have lids.

oden palette

metal dipper

plastic dippers

SUPPORTS

The word support simply means the surface on which you paint, whether canvas, prepared board, paper, or cardboard. The choice of surface is very important, as it affects the way the paint behaves. In general, textured surfaces are more pleasant to work on as they hold the paint to some extent, whereas on a shiny, non-absorbent one like hardboard it tends to slide around and takes a long time to dry. It is not possible, however, to recommend an "ideal" support; the choice must necessarily involve some trial and error, and will depend on your style of painting, the size of the picture, whether you are painting indoors or outdoors and, ultimately, what you feel comfortable with.

CANVAS AND CANVAS BOARD

Canvas is the most widely used support for oil paintings. It provides a sympathetic working surface, is light and easy to carry, and can be removed from the stretchers and stored without taking up much space.

Some of the unique properties of oil paint can only be brought out by the texture of canvas. In areas where paint is applied thinly, the grain is always visible and can become an integral part of the picture and contrast with any impasto work that hides the grain. When dry brush or

scumbling techniques are used, the paint will deposit on the top of the weave only, which results in a characteristic grainy paint surface through which the underlying paint layer still shows. The rough texture provides "tooth" to help the paint adhere during application, and the springy flexibility of stretched canvas enables a range of brush strokes that reflect both the shape of the brush and the way it is handled.

Canvases are available ready stretched and primed, but you can also buy stretchers and "raw" canvas and prepare your own, as shown here. Several different types of canvas are available from the larger art suppliers, but the cheapest, and ideal for the beginner to experiment on, is cotton duck. Linen is superior in that it is less abrasive, keeps its shape better, and tends to have less unpleasant knots in it. For a very coarse grain you can even use sacking or hessian, both of which were favored by Gauguin (1848–1903) and van Gogh (1853–1890).

Canvas does not have to be stretched; it can simply be glued to a plywood or hardboard panel (with rabbit-skin glue if possible), but this does sacrifice its flexibility. Before painting it must be sealed by priming with acrylic primer, or with a coat of size followed by an oil primer.

A popular alternative to canvas is

prepared painting board. This is made in a variety of surface textures, the less expensive being a rather unconvincing imitation canvas texture. This usually has a slightly greasy feel and does not hold the paint well, but some manufacturers produce a canvas board that is actually fabric stuck onto board.

BOARDS AND PLYWOOD

Plywood or the smooth side of hardboard is often used for small paintings, while some artists like to work exclusively on hardboard even for large-scale pictures. It is particularly suitable for those who like to apply paint thinly, with sable brushes, and a practical advantage is that it can be cut easily into any shape, either before or after painting (there are artists who consistently paint on triangular, hexagonal or completely irregular panels).

The paint will grip better if the surface is rubbed down with sandpaper and then primed with acrylic, which is slightly more

absorbent than oil primer. Large sheets of hardboard warp easily, and should be strengthened with a frame of wood battens on the underside.

PAPER AND CARDBOARD

Both paper and cardboard can be used provided they are primed first. One of the advantages of painting on paper is its lightness. A selection of stiff papers prepared with different colored grounds can easily be carried for an outdoor work session, and if you also take a knife and steel ruler the paper can be trimmed on the spot to the required size and shape.

Cardboard is also convenient for painting on, particularly if you like a smooth texture.

EASELS AND WORKSPACE

There is a wide range of easels on the market – the one you choose will depend on where you paint and how large your supports are. For example, if you intend to paint outdoors you will need a portable easel. There are several types of sketching easel, the cheapest probably being the wooden folding easel. These easels are fairly sturdy, but they are light, so they are easily upset in the wind, especially if you use a large canvas, which acts as a sail. Some sketching easels have spikes on their legs that can be sunk into soft ground. Artists sometimes tie the legs to an available tree stump, anchor them with string and tent pegs, or stabilize them by suspending something heavy, such as a rock, from the center. Lightweight metal versions of the traditional sketching easels are now available. These are very sturdy and are slightly easier to erect than the wooden ones, but they are more expensive.

Another easel useful for sketching outside is the combined easel and painting box. These easels are convenient – though rather expensive – items, which tend to be more stable than ordinary sketching easels. The paints are carried in the box part, which becomes a table and provides a very useful working surface.

There are many easels for use in the studio, including the traditional artist's donkey, a combined stool and easel that the artist straddles to work sitting down. These take up a lot of room, but are useful if you like to work sitting down or do a lot of detailed work.

Radial easels are sturdy objects usually made from a tough hardwood such as teak or beech. They have short tripod legs and the angle of the upright column can be adjusted. The height of the canvas can be changed by moving wooden clamps that hold the support in position. Canvases up to 76 in. (193 cm) can be supported.

Studio easels are very stable, with a firm H-shaped base. The painting rests on a shelf that also forms a compartment for brushes, and a sliding block holds the canvas firmly in position. The shelf height is quite easily adjusted and the canvas can be raised from 15 in. (40 cm) to 39 in. (100 cm) above the floor. Canvases of up to 63 in. (160 cm) can be used. They are easily tilted and can usually be wound

Radial studio easel

up and down by a ratchet device.

If you are very short of space, like to work sitting down, or work on a small scale, you might consider a table-top easel. These easels are very compact and relatively cheap. They can be tilted and the height of the support can be adjusted.

WORKSPACE

Few nonprofessional painters are fortunate enough to have access to a studio; nor indeed are all professional ones. Most people have to make do with a small, under-equipped room or just a corner of a room used by other people for other purposes. This can create problems, but these are surmountable with a little organization.

One problem is that oil paint is a messy medium and has an almost magical way of appearing on objects that seemed to be nowhere near it when you were painting. You get it on your hands without noticing, then you go and make a cup of coffee and it will be on the kettle, the mug, the spoon, and so on, ad infinitum. If you are working in a corner of a room, clean up as often as you can, including wiping your hands. Never wander about with a loaded paintbrush, and cover the equipment table with plenty of newspaper.

A more serious problem is lighting. The best light for painting is, of course, daylight, but daylight is unpredictable and changes all the

time, not only in variable weather conditions but also according to the time of day. Always try to position your easel so that the light source is behind you and coming over your left shoulder if you are right-handed.

One way of coping with the problem of poor light is to use artificial lighting which, while not as perfect as natural light, is at least constant. The best lights for painting are the fluorescent "daylight" ones, that can be bought either as ceiling lights or as lamps which can be fitted on to a shelf, table, or windowsill.

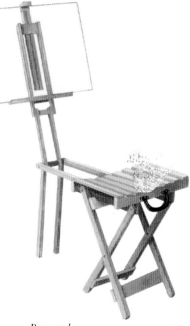

Box easel

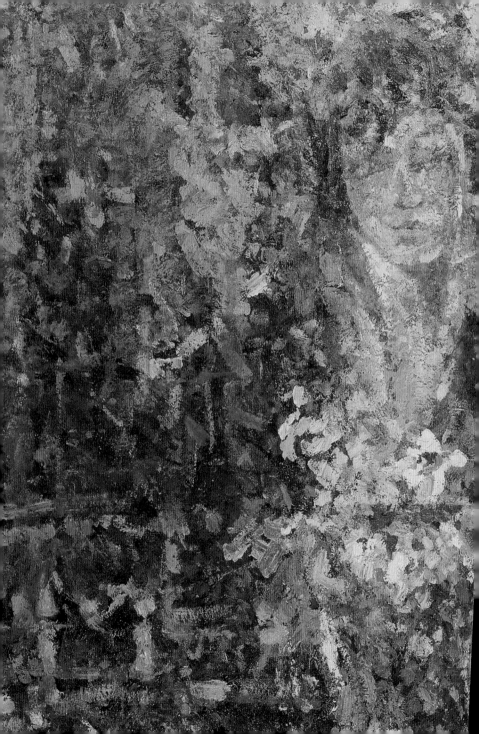